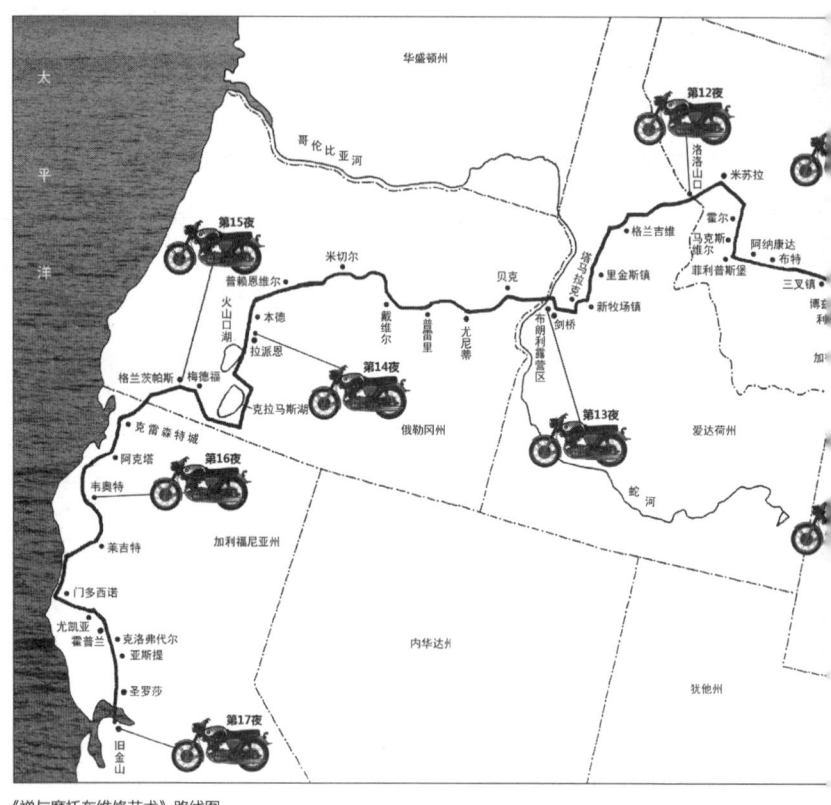

《禅与摩托车维修艺术》路线图

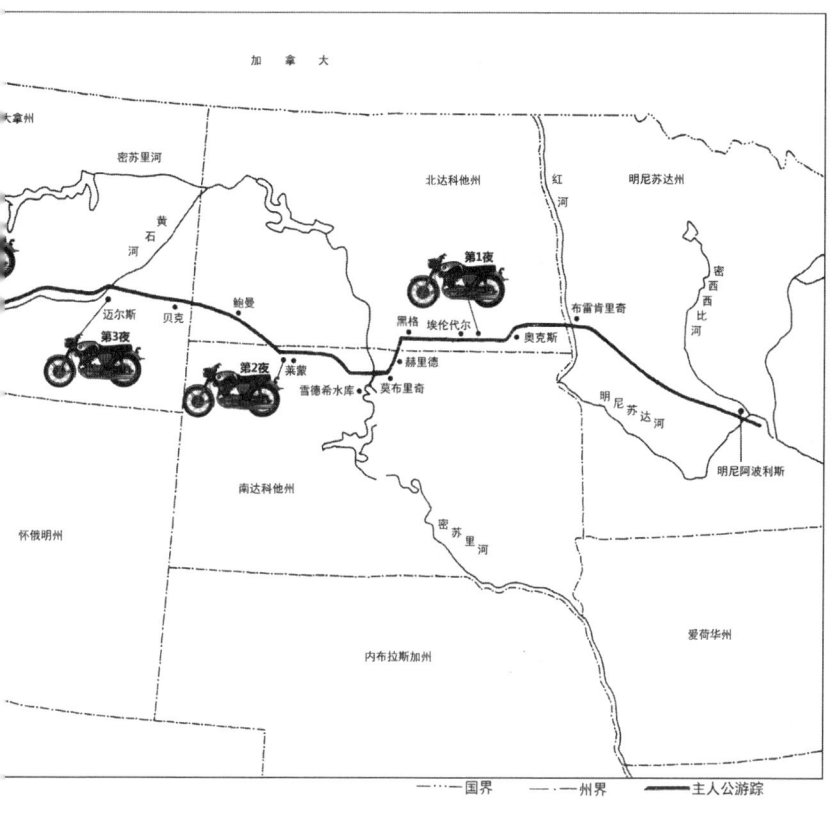

《禅与摩托车维修艺术》中所记录的这段横跨美国大陆的史诗之旅，事实上发生于一九六八年。上图为我们核对书中内容后重新绘制的路线图，并标明了准确的途经地点。

在这段旅途中，波西格、约翰和思薇雅曾分别使用波西格本人的相机拍摄了一些照片。不过，如今这些照片的原件已无处可寻。幸运的是，为了发表演讲，波西格曾将其中的十二张做成幻灯片。多年以后，他在一个破盒子里发现了这些脏兮兮的幻灯片，便将它们转成了数字格式。如今它们终于在中国首度与《禅与摩托车维修艺术》的读者们见面。

这本小册子第12页之后的插图（除第17页图外）便是这些幸存的照片，其中的场景在《禅与摩托车维修艺术》一书中基本都有所提及。感谢波西格的老友亨利·格尔（Henry Gurr）先生将它们提供给我，并一一确认其拍摄地点以及书中与其对应的段落。

——编者

罗伯特·M. 波西格晚年的一张照片
供图：威廉·马洛（William Morrow）

目 录
CONTENTS

关于作者 ◥ 走近波西格
ABOUT THE AUTHOR　　MEET ROBERT M. PIRSIG
◥ 与波西格对话
　　A CONVERSATION WITH ROBERT M. PIRSIG

关于本书 ◥ 生长的河——波西格和本书首版编辑的通信
ABOUT THE BOOK　　THE BENDABLE RIVER:
　　A CORRESPONDENCE BETWEEN ROBERT M. PIRSIG AND HIS EDITOR

拓展阅读 ◥ 《禅与摩托车维修艺术》背后的书
READ ON　　BOOKS THAT INFLUENCED THE WRITING OF ZEN AND THE ART
　　OF MOTORCYCLE MAINTENANCE
◥ 十周年纪念版作者手记
　　AFTERWORD OF THE TENTH ANNIVERSARY EDITON
◥ 二十五周年纪念版作者手记
　　INTRODUCTION TO THE TWENTY-FIFTH ANNIVERSARY EDITION

ABOUT
THE AUTHOR
关于作者

MEET ROBERT M. PIRSIG
走近波西格

罗伯特·M.波西格在维修摩托车。1975年　供图：威廉马洛公司

一九二八年，罗伯特·M.波西格出生于明尼苏达州的明尼阿波利斯。他很早就表现出化学方面的天赋，却因不能从中发现任何真实的终极意义而止步。他陷入抑郁，无法专注于学业，被迫从大学退学。然后他参军去了韩国，在那里的所见所闻使他转向东方哲学。他返回美国，在明尼苏达大学获得哲学学士学位，后来又去贝拿勒斯印度大学学习过一段时间东方哲学，之后再次回到明尼阿波利斯学习新闻专业，并成为自由撰稿人。在二十世纪五十年代后期，波西格和他的妻子南茜生了两个儿子——克里斯和泰德，同时他在蒙大拿州立大学短暂地教授过英文，之后去了伊利诺伊州的芝加哥大学学习哲学。

一九六〇年十二月，波西格患上严重的抑郁症，被送往伊利诺伊州精神病院，后又转至明尼阿波利斯的另一家医院。一九六三年，他在那里接受了电休克疗法。康复后，他于一九六七年开始写作一篇关于摩托车维修的轻松随笔，这就是《禅与摩托车维修艺术》的肇始。一九六八年六月，波西格给一百二十二家出版商写信，宣称自己想就精神与技术在

生活中彼此割裂的问题写一本书。一个月后，他与克里斯开始了一次摩托车之旅，这场旅行后来成为《禅与摩托车维修艺术》的基本情节。

波西格花费四年时间完成此书，最终由威廉马洛公司（William Morrow & Co.）在一九七四年出版，并立即获得评论与商业的巨大成功。此后，波西格沿着东海岸和加勒比一带航行，度过了七十年代余下的几年。其中，他于一九七五年在哈得逊河的游历成为《莱拉：一场对道德的探究》（Lila: An Inquiry into Morals，中文读本已出版）一书的基础，这是他的第二部哲学作品，于一九九一年出版。然而，在该书出版之前，波西格的儿子克里斯于一九七九年在洛杉矶惨遭杀害。波西格则经历了离婚，再婚，并于一九八一年生了一个女儿妮尔。整个二十世纪八十及九十年代，波西格都生活在瑞典和新罕布什尔州。二〇一七年四月二十四日，波西格于缅因州南贝里克的家中病逝。

《禅与摩托车维修艺术》英文第一版，精装，由威廉马洛公司于1974年出版

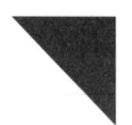

A CONVERSATION WITH ROBERT M. PIRSIG
与波西格对话

◎许多读者强烈感到,《禅与摩托车维修艺术》一书中的哲学话题难以理解,尽管他们非常喜爱这本书。对读者来说,完全理解其中的肖陶扩有多重要?

● 因人而异。其实有两本书在这里被揉为一体,一本关于思想,一本关于人物。如果读者只想了解里面的人物,那没问题,这本书依然具有可读性。如果读者想对思想了解得更多,那么续作《莱拉》不妨一读。

◎书中的"你"宣称,"我们的确需要重新珍惜个人的操守、对自我的信赖以及老式的进取心。"三十一年过去了,许多人(其中不少身居政坛)会同意这一说法。《禅与摩托车维修艺术》是一本指向内在的书,但是像前面这样的话有可能引起政治上的反应。你是有意的吗?当你写下这些文字的时候,你与书中的"你"是站在同一立场吗?

● 我没看到任何反对"个人的操守、对自我的信赖以及老式的进取心"的政治反应。无论共和党还是民主党似乎都声称这是他们的立场。没人站在台上高呼:"我们需要整齐划一!无趣一些,再无趣一些!"书中的"我"在这里喊出这种口号,是因为某种意义上,他自己就是个政客。他大发高论是为了赢取听众的广泛认可。

◎在《禅与摩托车维修艺术》一书中,你赞美了美国那些少有人走的小路,它使人们更能够欣赏到这个国家的人民和他们多样的生活方式。你现在还走这些路吗?如果走的话,你现在的感受是消极的还是积极的?

● 我现在就住在乡村,那里正在开发建设,我不愿意看到这些。但只要人口在增长,这是不可避免的。

◎你在书中写到艺术与技术的"分裂",近三十年我们是在朝着弥合这道裂缝的方向前进吗?计算机使技术更加人性了吗?

● 不,计算机反而更技术化了。这种分裂只能在更高的层面被弥合。讲述者在书中提到这一点,是为了给后面对良质的讨论打基础。良质是艺术与技术的共同基础。

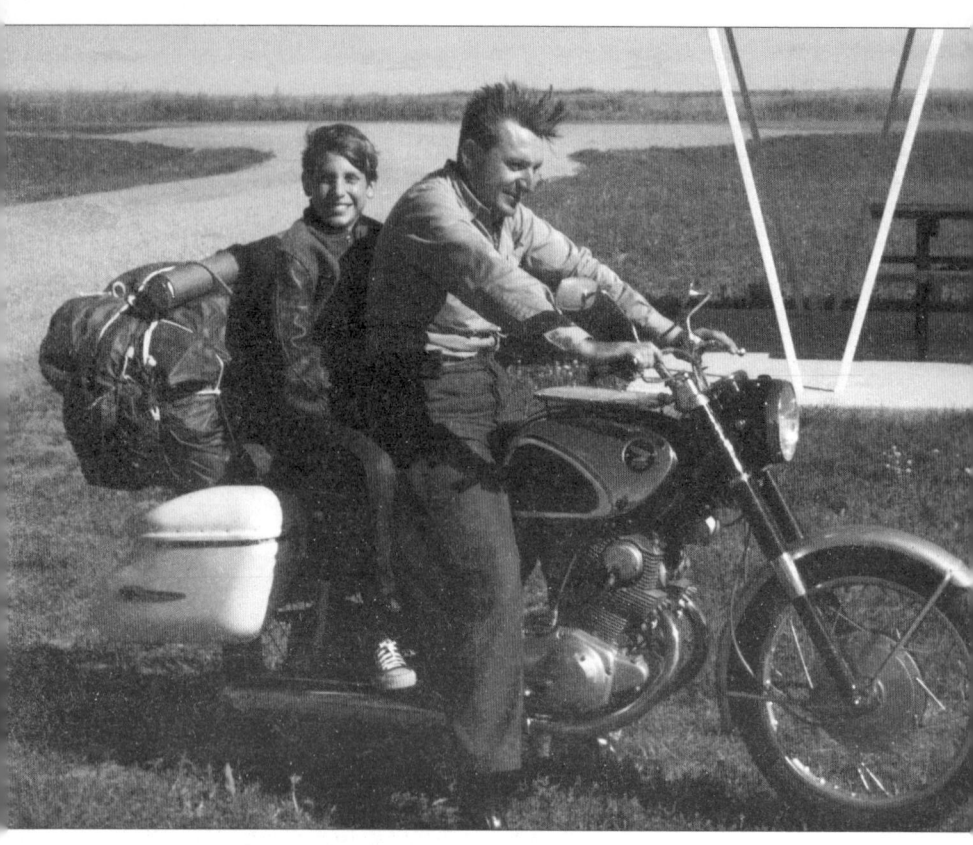

在布尔营国家历史遗址稍事休息　　拍摄地点：北达科他州的米尔纳

正文P38　　我突然注意到，大地现在变得一片平坦，没有小丘，甚至也没有任何凸起之处，这表示我们已经进入红河谷。很快就会到北达科他州了。

波西格注　　克里斯、鲍勃，第一天，北达科他州——这就是人们看到的那张黑白照片的原版。它起初被寄给了《禅与摩托车维修艺术》的英国出版商 BODLEY HEAD，并被印在封面上，从此广为传播。地点是北达科他州，在我们去奥克斯路上的一个休息区。当时大约是下午五六点钟，第一天即将结束。第3章里面描述的暴风雨是虚构的。

◎你说过，写作《禅与摩托车维修艺术》花费了数年，你能介绍一下创作本书的过程吗？是怎样创建了这样的结构，以及为什么会创造出这样一个复杂的观点？

① Dharma，佛教中的达摩，指佛的教法、佛法、一切事物和现象。
——编者注

② Eugen Herrigel (1884—1955)，德国哲学家，曾在日本任教，其间跟随日本弓道大师阿波研造 (1880—1939) 研究日本传统箭术，以期深化其对禅学的理解。后通过《禅与射箭艺术》一书将禅的思想传播至欧洲各国。
——编者注

● 实际上，这本书是从它的题目开始的。约翰·沙德兰是学哲学的，而且在学校的时候就对东方哲学抱有极大兴趣。事实上，我第一次见到他是在洛克菲勒基金的一次会议上，那次会议的主题是梵文的"dharma①"，他是那次会议的秘书。就像书里写的，我们常常一起骑摩托上路，看到有啤酒的地方，就停下来边喝边聊。我们经常聊到哲学话题，包括奥根·赫立格尔②的《禅与射箭艺术》(Zen in the Art of Archery)。我知道约翰不喜欢做摩托车维修方面的事情，而我喜欢，我想或许可以给他写一篇文章，就叫《禅与摩托车维修艺术》，使他理解我的观点。这个想法启发了我，这就是本书的由来。

这本书是有机地生长出来的，没有预先构划的方向，完全是追求完善的各种念头不断涌现的结果。那篇关于摩托车维修的文章，从摩托车扩展到了所有技术；我和约翰的分歧扩展到了古典和浪漫给整个世界带来的分裂。在我们进行了书中描述的那场旅行之后，我突然想到把这些念头放在关于整个旅行的叙述当中，使它们更具体，更有现实感。于是，整本书就成形了。

◎尽管连篇累牍，主题生僻，作者也鲜为人知，《禅与摩托车维修艺术》却空降各大畅销书排行榜，吸引了媒体广泛的注意，这令出版业大跌眼镜。你怎样评价此书的成功，为什么对它的阅读热潮持续不退？

● 我想这本书实践了它所包含的理念。我记得在写书的时候，我在心里对自己说："如果这是一篇有关良质的文章，那么你写的东西最好本身就是良质的一个例证。"

◎在被一百二十一家出版商拒绝之后，你一定对这本书的出版前景感到忧虑。许多作者可能会放弃希望，把书稿锁进柜子里。是什么使你决心让这本书面世呢？

● 并没有那么艰难。那一百二十二封信是通过穿孔纸带用电子打字机一次性打印出来的。一开始，有二十二家出版商表示有兴趣，但是在写作的四年中，这个数字降到了六。而这六家读过手稿后，只有一家愿意出版它。但是这正好，你只需要一家就够了。

摩托车满载行李,一场长旅即将开启!　　拍摄地点:北达科他州的米尔纳

正文P38　　出红河谷的时候,暴风雨的云层覆盖了天空,低低地压在我们头上。约翰和我在布雷肯里奇讨论过,决定继续走下去,直到必须停下来为止。

波西格注　　思薇雅、克里斯、约翰,第一天,北达科他州——去奥克斯路上的休息区。

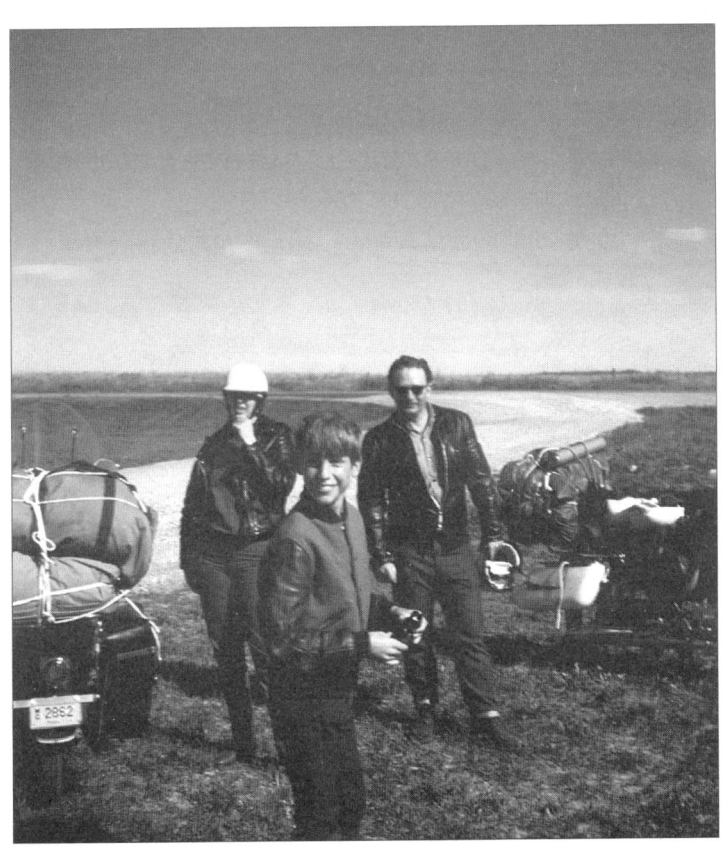

ABOUT
THE BOOK
关于本书

THE BENDABLE RIVER:
A CORRESPONDENCE BETWEEN ROBERT M.
PIRSIG AND HIS EDITOR

生长的河——波西格和本书首版编辑的通信

下文是波西格和本书编辑——威廉马洛出版公司的詹姆斯·兰迪斯之间的通信选摘。这些信件提供了迷人的视角，使我们洞悉作者的创造过程，以及作者与兰迪斯先生之间的珍贵友谊，这份甘霖般的友谊给了作者莫大的支持。从这些信中，我们能读到一个关于一本书突破重重质疑得到出版，并取得极大成功的非凡故事。这个故事开始于一九六八年六月，罗伯特·波西格将最初的"自荐信"寄给时任威廉马洛出版公司总编辑的约翰·C. 威利，信中说自己要写一本"名字有点怪"的书。

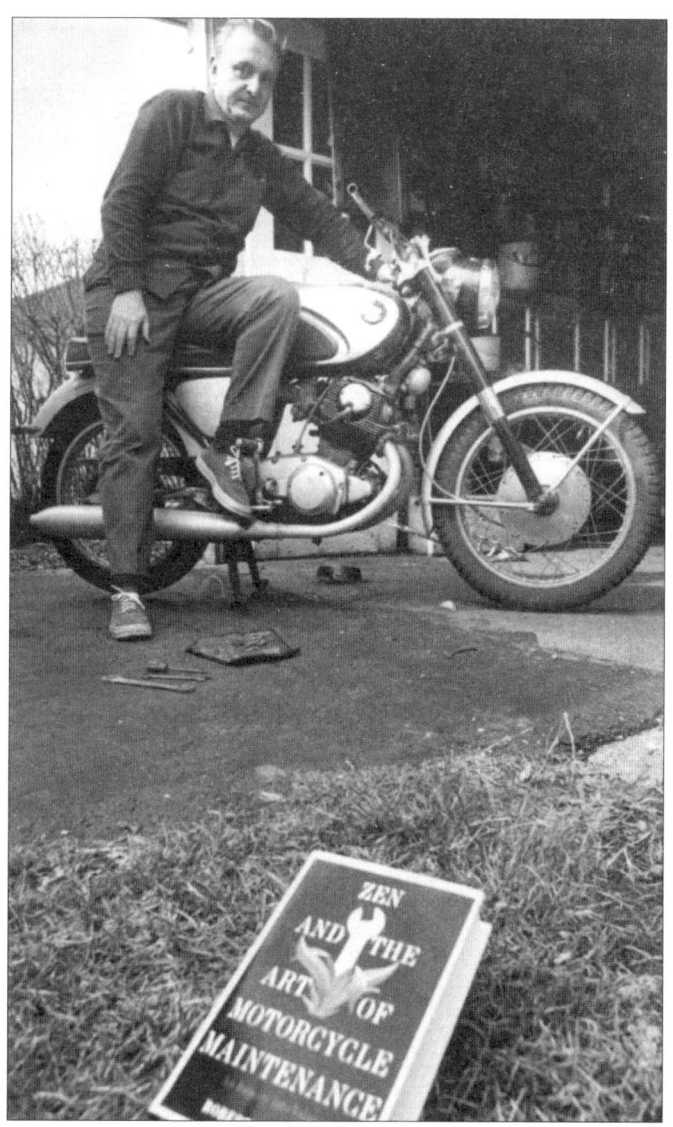

罗伯特·M.波西格与《禅与摩托车维修艺术》第一版的合影,1974年4月17日。摄影:克雷格·鲍克(Craig Borck)。《圣吉罗先锋报》资料照片

● 一九六八年六月六日

尊敬的威利先生：

　　我正在写一本书，它的名字有点怪，叫作《禅与摩托车维修艺术》。我正在寻找一家愿意出版它的公司。

　　这本书，如其名字所说，与禅有关，也与摩托车维修有关，但它也关系到精神感受与技术思维的整合。书中提出，上述二者的分裂是我们这个时代之所以充斥着不满的深刻根源，并给出了一些非正统的解决之道。

　　随信奉上两页样稿，如果你们有兴趣读到更多，请告诉我。

　　谢谢。

<div style="text-align:right">罗伯特·M. 波西格</div>

● 一九六八年六月十日

尊敬的波西格先生：

　　约翰·威利把您六月六日关于《禅与摩托车维修艺术》一书的信件转交给了我。这本书听起来非常吸引人，我们非常乐意考虑，请惠寄全稿或已完成部分的稿件。您可以直接和我联系。

> 您诚挚的，
> 詹姆斯·兰迪斯
> 编辑

由此，开启了二人绝无仅有的创造性合作。波西格和兰迪斯在接近四年的时间里彼此通信，交流进展和思想。波西格在谋篇写作之际，需要将分散在大约三千张四英寸乘六英寸卡片上的写作体系化用到书中，这一过程颇为痛苦，而兰迪斯一直在鼓励他。使这一密切的编著关系尤为不同寻常的是，它发生在图书出版合同尚未签订之时。

● 一九六九年一月五日

敬爱的兰迪斯先生：

　　现在距圣诞节结束又过去了几天，按照原来的估算，这个时候应该已经写完《禅与摩托车维修艺术》了。但这本书离写完还差得远，只好写这篇进度汇报来代替了。

　　进度情况是：我对现在的写作进展极为满意。在十月初的时候，我就清楚地感觉到，这本书已经突破险阻，不用再艰难地爬坡了。从那以后，我一直走在漫长、愉快的下山路上。

　　快到八月底时，我对散文形式无法将读者带入情境感到越来越不满，转而采用一种全新的叙事散文的形式。这篇散文由一个骑摩托车横跨大陆的人用第一人称现在时态讲述出来。我和我儿子去年夏天的旅行提供了一个天然的

叙述框架……

 某种意义上，这本书现在已经完成了，需要的只是写出来。整个大纲被写在差不多三千张四乘六英寸的卡片上，在十二月已经完成了，详尽到了段落的安排。实际上，是五个不同的大纲，分别被命名为："事件""人物""维修部分整体架构""禅部分整体架构"，以及"高度"。这五个部分被相当细致地交织在一起，以达到彼此强化的效果，并令全书前后统一……

 我起初估算的完成时间是来不及了，至于是否再做一次估算，我相当犹豫。但是，我们先约在九月份吧。我想你会对这个故事的质量感到惊喜的，我不想因匆忙而失手。

<div style="text-align: right;">
您无比真诚的

罗伯特·波西格
</div>

● 一九七〇年三月三日

敬爱的兰迪斯先生：

又到了《禅与摩托车维修艺术》的半年汇报时间，如下：

第一稿已完成。

难以相信，但它写出来了。目前仍然丑陋不堪、臭不可闻、支离破碎，内容比重也不合理……任何人读了都不能不感到恶心……但是它写出来了，一共十二万字，里面的故事，假以耐心和好运，可以被加工成相当有力度的东西。

所以，我要换换角色了……从无所不知的预言家变成一个徜徉其中的观光客，我的两肩轻松多了。一字未改地写了整整两年，真是身心疲惫。但我确信，如果不这么干，这第一稿永远都写不出来。现在，每一个部分不仅可以被单独评价，还可以被置于全书中进行评价。

良好的祝愿，

鲍勃·波西格

从完成的第一稿来看，很明显，写作《禅与摩托车维修艺术》在各个方面都有很大难度，智力上，商业上，还是组织结构上。

23

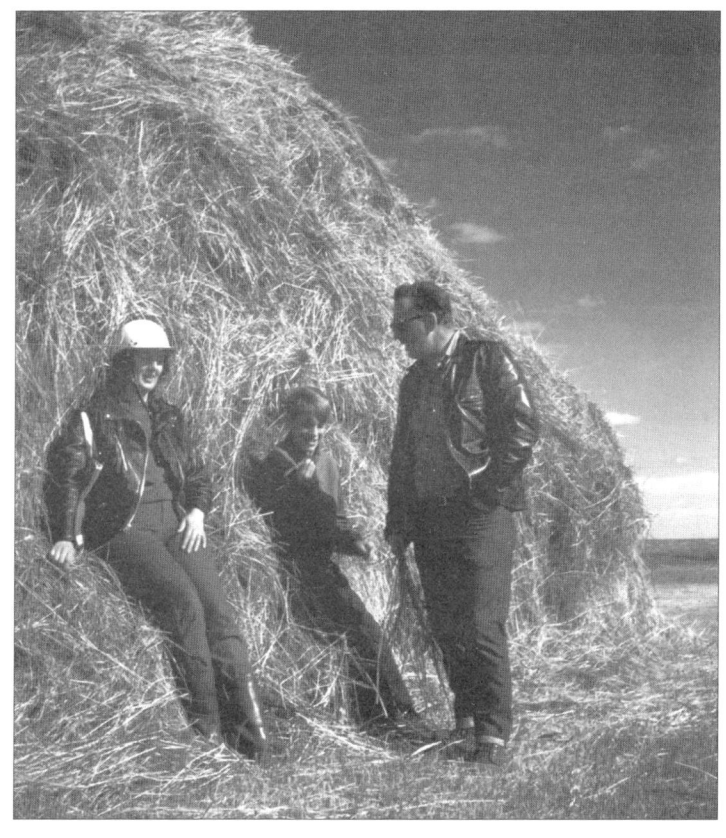

这样的干草垛今天几乎看不到了,然而在北达科他州的这块土地上,你会看到形如巨兽的干草垛像房子一样座座耸立!
拍摄地点:北达科他州的米尔纳

正文P39　　　　但是我们走不了太久了,太阳已经被遮住,迎面吹来的风很冷,我们被笼罩在深浅不一的灰暗当中。
　　　　　　　　暴风雨的云层似乎非常厚实,虽然草原辽阔无边,但是头上这正要袭来的巨大雨云却更令人害怕。现在我们只能看它的脸色行驶。它什么时候什么地点下来,我们无法控制,唯一能做的只是看着它越来越近。
　　　　　　　　刚才我们曾经看到前方有一座小镇、一些小型建筑和一座水塔,现在它们已被乌云笼罩,消失了。暴风雨随时会来。现在看不到任何城镇,所以我们必须骑快些。

波西格注　　　歇脚处的干草垛,北达科他州,第一天——去奥克斯路上的休息区。

● 一九七二年十一月二十一日

敬爱的波西格先生：

　　读过你的书后，我便陷入了沉思。自我上次写信给你，告诉你我有多么喜欢我所读到的一切之后，我又用了几天读完了全书，现在，尽管带着迟疑，但我非常愿意告诉你，我爱这本书，它充满智慧、趣味和忧伤，它教给我一些东西。这是一本我非常乐意去出版的书，尽管——这就是我们有些迟疑的地方——我不完全确定应该怎么做，或者，我是否应该停下来。

　　假设你还没有卖出这本书，我想在这儿试着解释一下我恐怕要称之为麻烦的事情。很多事情，到头来都会庸俗地归结到，金钱……我最担心的金钱问题，是制作这本书的花销。因为，你知道，这是一部非常长的作品，粗略估计大约有二十万字。这种长度的书对出版商来说是实实在在的挑战，因为他必须以较高的价格出售，才能收回单单是制作的成本……更糟糕的是(至少对我而言)，很难估计像这

样一本书的市场。我有时认为这部作品堪称经典，不能用商业价值来衡量。当然了，虽然我们在一个商业环境中谈论经典时，往往是指那些年复一年长销不衰的作品。这是一部大作，一部艰深的作品，至少在表面上说，很难有巨大的大众吸引力……不排除本书可能有广泛而数量可观的读者，但我不能打这个赌……

　　期盼听到你的想法，我非常希望我们最终能使它面世。

最好的祝愿，

詹姆斯·兰迪斯

高级编辑

在收到波西格于一九六八年写的自荐信的一百二十二家出版商当中，威廉马洛是唯一一家愿意出版其最终手稿的公司，他们与波西格在一九七三年签订了出版合同。詹姆斯·兰迪斯将《禅与摩托车维修艺术》介绍给他的同事时说，它将成为一部经典。

编辑陈述 （一九七三年四月）

书名：禅与摩托车维修艺术

提要：从最终意义上说，这是一部关于活着和怎样活着，并使你深思为什么的书。这本书可以从多个层面来阅读……简要概括如下：这是一个男人的自传体作品，故事发生在他和他儿子一起进行的一场摩托车旅行中。这个男人曾经发过疯，他认为自己现在是和发疯前的那个人完全不同的另一个人。在这场摩托车之旅中，这个男人，也是书中的讲述者（一定不要把他和罗伯特·波西格本人混淆），必须面对自己，还有曾经的自己，以及他十一岁的儿子克里斯。克里斯被诊断出具有"精神疾病的征兆"……这本书睿智得难以置信，我愿意打赌，它很可能是一部天才之作，并将跻身经典之列。

他们面前还有更多的工作要做：制作这样一部巨著并令其成功上市，需要长达一年的艰苦准备，从选择精准的副标题，到努力争取并获得能奠定此书经典地位的评论家赞誉，从而使其成为美国文学史上最具独创性、最激动人心的作品之一。

● 一九七三年六月十五日

亲爱的吉姆：

　　昨天夜里，我妻子南茜做了一个令她很焦虑的梦，你也出现在梦中，手里拿着这本书，一面是精装的，一面是平装的，但是书的名字意外地改成了《生长的河》。她不知道这个名字是怎么来的，但是我对她说，这个名字我越想越觉得不赖。她对我的幽默置之不理，说标题后面还有好几行副标题，她记不清楚，但结尾是"一场对价值的探寻"，她感觉非常糟糕。

　　后来，我们在一次宴会上把这个副标题念给大家听，结果每一个人都强烈反对（特别是凯特·贝里曼，那个诗人的妻子）。普遍反应是这个副标题破坏了书名的韵味，就像一个过早的解释把一个笑话搞得了无趣味，结果使整本书听起来像一篇优秀的毕业论文。

<div style="text-align:right">鲍勃·波西格</div>

● 一九七三年六月十九日

亲爱的鲍勃：

　　无论在人们身上尝试什么事情，宴会都是一个糟糕的场合，特别是对于他们可能并不理解的东西（因为距离——太远或太近）。当然，你或许认为你的朋友们并不属于这种情况，因此他们的判断就更值得考虑，我们都看重那种第一反应之类的东西。但是我认为，说到底，他们怎么说并不重要，而你理应对他们的话和这些话正确与否都泰然处之……我的个人感觉是，"一场对价值的探寻"非常棒，它可能是我们任何人所能想出来的，最简短又最准确的概括……这个书名同样独特、美妙，特别是对一个正在考虑是否购买或阅读的人来说，但是对于其他人，至少是喜欢这本书的人而言，它的含义过于宽泛了……如果需要的话，就算整个世界是一场大宴会，我也愿意和你并肩战斗，不改初衷。

<div style="text-align:right">吉姆</div>

詹姆斯·兰迪斯笔记节录（一九七三年八月二日）

乔治·斯坦纳[1]，无疑是当今世界上享有最高声誉的作家和思想家之一……他在读过此书之后写信给我，说"这是一部顶尖之作"，并将其与陀思妥耶夫斯基、布洛赫……以及普鲁斯特和柏格森的作品置于同样的高度。他"带着内心的狂喜"称《禅》为一部"极其重要的著作"。斯坦纳还写信给《纽约客》，希望能发表一篇对此书的评论，尽管很显然，正是《纽约客》推荐此书望其作评……我认为一个有着像他这样深厚学养和巨大声望的人，对我们这部即将上市的作品做出如此反应，具有极其重要的意义……正如我所希望的，从外界可能对此书做出的反应，以及从我们内部读过此书后已做出的反应来看，情况越来越清楚，罗伯特·波西格的这部作品，从任何标准上看都是一个重要事件，而且很快就将被公认为我们这个时代最重要的著作之一。

[1] George Steiner，当代最杰出的知识分子之一，不列颠学会会员。1929年出生于巴黎，先后在哈佛大学和牛津大学获得硕士及博士学位，2007年获得阿方索·雷耶斯国际奖。——编者注

READ ON
拓展阅读

BOOKS THAT INFLUENCED THE WRITING OF ZEN AND THE ART OF MOTORCYCLE MAINTENANCE
《禅与摩托车维修艺术》背后的书

《禅与摩托车维修艺术》一书中有很多关于世界观的探讨,下面这些书籍,在罗伯特·M.波西格的人生中,影响了他观察和探究世界的方式。

- 希利尔：《希利尔讲世界史》
 A Child's History of the World by V.M. Hillyer
- 丹尼尔·笛福：《鲁滨逊漂流记》
 Robinson Crusoe by Daniel Defoe
- 乔纳森·斯威夫特：《格列佛游记》
 Gulliver's Travels by Jonathan Swift
- 托马斯·贝雷·阿尔德里奇：《一个坏男孩的故事》
 The Story of a Bad Boy by Thomas Bailey Aldrich
- 《船之书》
 The Book of Old Ships
- 《康普顿插图百科全书》
 Compton's Pictured Encyclopedia
- 玛格丽特·米切尔：《飘》
 Gone with the Wind by Margaret Mitchell

- 玛丽·雪莱：《弗兰肯斯坦》

 Frankenstein by Mary Shelley

- 布莱姆·斯托克：《吸血鬼伯爵德古拉》

 Dracula by Bram Stoker

- 欧内斯特·海明威：《太阳照常升起》

 The Sun Also Rises by Ernest Hemingway

- 欧内斯特·海明威：《永别了，武器》

 A Farewell to Arms by Ernest Hemingway

- 埃德加·艾伦·坡作品

 Edgar Allan Poe

- 诺斯罗普：《当东方遇到西方》

 The Meeting of East and West by F.S.C. Northrop

- 老子：《道德经》

 Tao Te Ching by Lao Tzu

- 阿道司·赫胥黎：《美丽新世界》

 Brave New World by Aldous Huxley

- 沃尔特·李普曼：《道德绪论》

 A Preface to Morals by Walter Lippmann

- 拉达克利西南：《印度哲学史料集》

 A Source Book in Indian Philosophy by Sarvepalli Radhakrishnan

- 埃里克·霍弗：《狂热分子》

 The True Believer by Eric Hoffer

- 奥根·赫立格尔：《禅与射箭艺术》

 Zen in the Art of Archery by Eugen Herrigel

- 杰克·凯鲁亚克：《在路上》

 On the Road by Jack Kerouac

- 铃木俊隆：《禅者的初心》

 Zen Mind, Beginner's Mind by Shunryu Suzuki

AFTERWORD OF THE TENTH ANNIVERSARY EDITON
十周年纪念版作者手记

这本书中多次提到古希腊人的观念并进行了阐述，但是有一个观念没有提到，就是他们对时间的观念。在他们看来，未来在他们的背后，而过去则在眼前渐行渐远。

仔细想想，这种时间隐喻比我们当前的观念更为准确。谁能真的面向未来？我们能做的不过是用过去来构划未来，虽然过去一再告诉我们，这种构划往往是失败的。谁又能真的把过去抛诸脑后？我们还可以知道些什么？

在《禅与摩托车维修艺术》出版十年之后，古希腊人的这种时间观恰好适用。我们背后是什么样的未来，我真的不得而知，但是发生过的，并且正在眼前逝去的一切，全都清清楚楚。

当然，没有一个人能料想到发生的一切。回想当初，在经历了一百二十一次拒稿之后，终于有一位编辑，按照行业惯例，预付给了我三千美金稿费。他说，这本书迫使他思考，自己从事出版到底为了什么。他还说，虽然这笔钱十有八九就是全部的稿费了，但请我不要灰心，对于这样一本书来说，钱不是目的。

他说得对。但是等到本书真的出版之后，却引来评论狂潮，进入畅销书排行榜。杂志、广播、电视的访谈纷至沓来，还有电影邀约、国外译介、无穷无尽的演讲邀请，以及，周周都有、月月不绝的读者来信。在这些信件中，写满了这样的问题：为什么如此这般？那里到底怎么回事？这里是不是遗漏了什么？你究竟有什么企图？他们的问题里带着种种困惑不解。他们确信这本书

之外还有更多故事，他们想知道得越多越好。

真的没有"更多故事"可讲了，也没有什么深藏不露的图谋。不写这本书未尝不可，但写出来似乎就能感受到更高层次的"良质"，如此而已。然而随着时间远去，我看到围绕本书的思考还在日益增长，现在，我似乎能够做出一个更为充分的回答了。

有一个瑞典词汇，叫 kulturbärer，可以翻译为"文化承载者"，但还是有些词不达意。这不是一个美国人常用的概念，虽然它很合用。

一本承载文化的书，就像一头骡子，背负着文化的重担。没有人能通过坐下来细心盘算写出这样一本书。此类书的产生有极大的偶然性，就像股票市场的突然波动。许多高水准的图书能够成为文化的重要组成部分，却不属于这种文化承载者。因为它们只是现有文化的局部彰显，却没有塑造文化本身。比方说，它们能够以符合社会规范的关切态度探讨精神病，然而除了说这是大脑病变或衰退，它们对于精神病没有提供任何新的解读。

文化承载者则不同，这种书向传统的社会价值观发起挑战，而且通常出现在社会文化发生变革的时代，这样的时代欢迎新思想的冲击。此类书并不必然是高质量的作品。《汤姆叔叔的小屋》算不上文学杰作，但它出现在整个文化都在反对奴隶制的时代节点上，因此成了那个时代的文化承载者。人们将它作为新文化的标杆，使它获得了席卷全国的巨大成功。

书中对南达科他州那次露营的描写就是照着这张照片来的!
拍摄地点:南达科他州雪德希水库旁边的卢埃林·琼斯活动区

正文P72—P73　我们从莱蒙骑上一条乡间小路,似乎骑了好久好久,人已经累瘫了,但是实际上并没走多远,因为太阳还没有下山。这个露营地已经很久没人来过了,这倒不错。但是还有不到半个钟头,太阳就会完全下山,而且我们的精力已经耗尽了,这是最大的问题。
　　……后来我发现这里风太大,就是那种高原的风。这里似乎是半沙漠地带,所有的东西都被烧掉了,而且十分干旱,只有一个湖在我们下方,它只能算是个大蓄水池。

波西格注　南达科他州的露营地,早晨——第6章开头关于南达科他州露营地的描写反映的便是这一场景。

《禅与摩托车维修艺术》的成功,看起来也应归功于时代对这种文化承载者的需求。书中描述的非自愿电击疗法,被视为对人类自由的侵犯,在今天已被禁止。时代变了。

这本书同样出现在文化剧变的关键节点。在物质主义大获全胜之际,嬉皮士不屑一顾,保守派无所作为。物质主义的成功曾经是美国的梦想。数百万欧洲农民对它梦寐以求,并来到美国追逐这个梦想,在这块新大陆,他们和他们的子子孙孙,将永无匮乏之日。可是现在,他们在蜜罐里长大的后代把这个梦想踩在脚下,说这不过是些破烂。他们想干什么?

嬉皮士知道他们要什么,并美其名曰"自由"。可是在经过彻底的分析之后,所谓"自由"纯粹是一个消极的目标,是一个很糟糕的词。嬉皮士们没有提出改良的方向,只制造出一些吸引眼球却转瞬即逝的东西,其中有些返璞归真的主张,日渐演变成纯粹的堕落。返璞归真自有其趣味,但是当成严肃的毕生事业就不大可行了。

这本书,在物质主义的成功之外,指出一条更严肃可行的道路。它不仅扩展了"成功"一词的内涵,超越了"找个好工作""日子过得顺当"这类世俗的成功标准,更在精神标准上超越了所谓的"自由"。它指出一个积极的方向,值得我们为之奋斗不止。我想,这就是本书获得成功的主要原因。整个社会正在寻找的东西,在这本书中恰好出现了。在这个意义上,它成了文

39

在休息区，和书中讲的一模一样！
拍摄地点：蒙大拿州贝尔图斯山口高速路上的一个路边休息区

正文P147	我们在路边停下来，拍了一些照片作纪念，然后从小路走到悬崖边。
波西格注	约翰、克里斯、鲍勃在盘山道上——你肯定马上就能想起从雷德洛奇到库克市那条路上的这个地方。

化承载者。

我像古希腊人一样注视着眼前这正在远去的十年，一团浓重的阴霾将它笼罩：克里斯死了。

他被杀害了。在一个星期六的晚上，大约八点钟。那是一九七九年十一月十七日。当时他在旧金山，是禅修中心的一名学生。那天他离开禅修中心，打算穿过一个街区，去拜访住在海特大街的一位朋友。

根据目击者描述，一辆小汽车从街上开过来，停在他身边。两个黑人男性从车里跳出，其中一个从后面扭住他的胳膊，使他无法逃脱，前面的那个掏空他的口袋后一无所获，因此勃然大怒。他用一把大号的厨房刀威胁克里斯。克里斯说了什么，目击者无法听清，只看到歹徒更加愤怒。然后克里斯又说了些什么，使歹徒暴跳如雷，扬起刀子朝克里斯的胸膛刺了进去。然后二人开车跑掉了。

克里斯伏到路旁的一辆车上，努力支持了一会儿，不让自己瘫倒在地。过了一会儿，他踉踉跄跄地走到马路对面，停在海特大街和奥克泰街交界处的路灯下面。然后，由于肺动脉被切断，鲜血充满他的右肺，他在人行道上倒下去，死了。

我活了下来，不为什么，只是一种惯性。在他的葬礼上我们得知，那天早上他刚买了一张飞往英国的机票，在那儿，我的第二任妻子和我住在海上的一艘帆船里。然后，我们收到了他寄来

41

前一张照片还日光明媚，这一张云雾已经遮住太阳，可见两张照片的拍摄相隔有一段时间
拍摄地点：蒙大拿州贝尔图斯山口高速路上的一个路边休息区

正文P147　　在我们这条路的正下方有一辆摩托车，车子小得几乎都快看不见了。我们把自己裹得更紧，以抵挡迎面而来的寒风，然后继续向上骑。

波西格注　　克里斯、约翰、思薇雅在盘山道上。

的信件，上面奇怪地写着："我从没想过我能活到自己的二十三岁生日。"再过两周，就是他的二十三岁生日了。

葬礼之后，我们收拾他的物品，包括他刚买的一辆二手摩托车。我们把所有物品装上一辆旧卡车，再一次踏上这本书中描述过的那些西部山区和沙漠之路。在这年终岁尾的时令，山林和草原都被白雪覆盖，有种静默的美。到了明尼苏达他祖父的家里，我们的心情都平静了许多。在那儿，我们把他的物品放进阁楼，保存至今。

我时常沉浸在哲学问题里，一遍一遍地琢磨，让它们在我的脑子里一圈又一圈地盘旋，直到答案浮现，或者，变成死结，把我的心智推向危险的边缘。现在，这个挥之不去的问题是："他去哪儿了？"

克里斯去哪儿了？那天早上他刚买了一张机票。银行里有他的账户，抽屉里塞满他的衣服，他有好几架的图书。他是个活生生的人，真真切切地存在过，这个地球上有他的位置，有他生活的轨迹。可是，现在他在哪儿？他从火葬场的烟囱上离开了吗？他在我们捧回的装有他骨殖的小盒子里吗？他正在我们头顶的某块云朵上拨弄黄金的竖琴吗？都是胡思乱想罢了。

有个问题必须要问：使我无法释怀的到底是什么？只是我头脑中的幻影吗？如果你曾在精神病院待过，那么这绝不是一个随随便便的问题。如果他并不仅仅是一个幻影，那他去哪儿了？真实存

43

珍妮·狄威斯、鱼、门廊，在狄威斯家中，一九六八年七月
拍摄地点：位于蒙大拿州加勒廷盖特韦的棉白杨峡谷中的狄威斯家

正文P183　……然后珍妮·狄威斯从门廊的转角处捧了一盘啤酒过来。她也是一位画家，而且善解人意。艺术家从盘子里抓起一罐啤酒，没有与她握手寒暄，她赞同地笑了……

波西格注　珍妮·狄威斯和邻家男孩——这就是珍妮在一九六八年夏天的样子。这一场景出现在第14章。在书中珍妮说："邻居正好送来一堆鳟鱼当晚餐。真是棒极了。"珍妮后来对我说，她绝不可能说这样的话，可是已经来不及修改了。

在的事物可以像这样消失得无影无踪吗？如果可以的话，那么物理学的各种守恒定律就靠不住了。可如果我们相信物理学，那么这个消失不见的克里斯一定不曾存在过。想啊，想啊，还是想不通。他以前也曾这样跑开躲着我，故意惹我不高兴，或迟或早，他总会出现。但是现在，他还会出现吗？到底谁能告诉我，他去哪儿了？

我最终意识到，要回答"他去哪儿了"这个问题，必须首先回答"那个不见了的'他'到底是什么"。于是我的思想不再打转。按照长久以来的文化习惯，我们总是把人理解为主要由物质构成的某种东西，比如血、肉。如果坚持这种观点，我的问题就回答不了。克里斯的血肉的确在火葬场化为尘埃，从烟囱上飘散了，但是，那不是克里斯。

必须明了，我所日思夜想的克里斯，不是一具肉身，而是一种形态，虽然这个形态也包括克里斯的血肉之躯，但躯体只是其中的一部分而已。这个形态大过克里斯和我的总和，以一种我们都不曾完全理解也不能任意操控的方式把我们联系在一起。

现在，克里斯的躯体，作为这个形态的一部分，消失了。而这个形态的整体依然存在，一个巨大的空洞在它中心撕裂开来，那就是我的心疼痛不已的原因。这个形态需要附着于某物却求而不得。丧亲之人在坟茔前久久不愿离去，对亡人的随便什么物件或代表都恋恋不舍，这也许就是原因。这个形态必须找到新的物质实体来获得支撑，延续自身的存在。

45

山间牧场，在狄威斯的宅地，一九六八年七月
拍摄地点：位于蒙大拿州加勒廷盖特韦的狄威斯的宅地

正文P183　　约翰告诉他这次真是棒极了，正是他们夫妇长久以来想要做的事。
　　　　　　思薇雅补充道："就是想出来到空旷的地方走走。"
　　　　　　狄威斯说："蒙大拿州空旷得很。"他和约翰还有那位艺术家朋友，热络地谈起蒙大拿和明尼苏达之间的差异。
　　　　　　在我们的下方有一匹马，正安静地吃草。再过去有一条湍急的小溪。

波西格注　　克里斯，在马背上。

过了一段时日，我越发认识到，这些想法和许多原始文化中的认识非常接近。如果你把那个形态中除去了血肉的部分拿出来，称之为"精神"或"鬼魂"，那么这样的言语就呼之欲出了：克里斯的精神，或者，克里斯的鬼魂，正在寻找一个新的躯体进入。当我们听到这一类"愚昧"言谈时，总是斥之为"迷信"，因为我们将所谓"精神"或"鬼魂"理解为某种脱离肉体的物质。但是实际上，可能完全不是这样。

世事难料，仅仅几个月后，我妻子意外怀孕了。认真讨论之后，我们都认为这不该发生，也不该继续。我已经五十多岁了，我不想再从头养育一个孩子。我早已身心俱疲。所以我们最终下定决心，并依照要求和医院预约了日期。

然后，发生了非常奇怪的事情，我终生难忘。在我们最后一次仔细梳理了整个决议之后，突然有一种分离发生了，仿佛就在我们坐着谈话的当口，我的妻子正离我远去。我们眼看着彼此，一如既往地交谈，但是就好像火箭发射后在照片里被定格的那些瞬间，两级火箭在空中正在脱离彼此。你以为你们还在一起，然而猛然间，你发现你们已经永远分离。

我说："不对，等一等，不能这样。"到底是什么，我也说不清，但是我有强烈的预感，不能再继续了。那真是让人后怕，现在我看得很清楚了。那是克里斯。他在最后时刻以深广的形态昭示自己的存在。于是我们改变了决定。现在我们意识到了，如

马、乔西·狄威斯、罗伯特·狄威斯教授、克里斯,一九六八年七月
拍摄地点:位于蒙大拿州加勒廷盖特韦的狄威斯的宅地

正文P183　　他们又开始谈狄威斯在峡谷里的家园,狄威斯已经住了多久,还有教艺术的工作是怎样的,等等。约翰实在很有本领闲聊,而这正是我最不擅长的。所以我只是静静地听着。

P184　　……不知多久之后,我听到约翰说:"哪儿来的电影明星?"我知道他指的是我和我戴的太阳眼镜。

波西格注　　乔西、鲍勃·狄威斯、克里斯——骑在马背上的是狄威斯最小的儿子乔西,狄威斯和克里斯站在旁边。

果坚持最初的想法，等待我们的将是多大的变故。

所以，我想可以这样说，用这种古老的世界观来看，克里斯最终坐上了他的航班。这回，他成了一个女孩，名叫妮尔，而我们的生活再次充满生机。空洞被弥合了。当然，我还是常常思念克里斯，记忆的片段绵绵无尽，但是，我不再执着于那个永远不会回来的血肉之躯，那种执着是有害的。我们现在在瑞典，我母亲的祖籍。我正在写作第二本书，是这本书的续集。

妮尔使我们在养育子女方面收获了新知。如果她大哭大闹，或者有意跟我们作对（这比较少见），我们并不感到头疼。因为总有克里斯的静默与之平衡。我们现在深深地感知到，虽然名字和面孔一代一代都在改变，却有一种让我们相亲相爱的深广形态，始终生生不息。说到这种深广的形态，本书的最后一行是它的明证。我们赢了。情况正在慢慢好起来，我们几乎可以这样期待。

ooolo99ikl;i., pyknulmmmmmmmmm　　　111

（上面这行是妮尔所作。她转转悠悠跑到打字机旁边，突然在键盘上乱敲乱打，然后出神地看着。克里斯也曾用同样的目光看过同样的场景。如果编辑保留这行文字，这将成为她首次发表的作品。）

罗伯特·M.波西格

瑞典，哥德堡

一九八四年

书中的"我"和"克里斯"在波斯曼山中的露营点,原文精准再现!
拍摄地点:位于蒙大拿州波斯曼的棉白杨峡谷

正文P262　　我们来到一个平坦的地方,一个大圆丘在山坡上拱了起来,我告诉克里斯今天就到这里为止。他似乎很满意、很高兴,或许,他终究有了一些进步。

波西格注　　棉白杨峡谷中的克里斯——在第19章中是这样描述的:后来我回到帐篷旁边,听到里面有声音,知道克里斯醒过来了。我探头进去看他,他正静静地躺着。他一向醒来很慢,在他开口之前,几乎需要五分钟的缓冲时间。这时,他正眯着眼睛看太阳。(正文P266。)

INTRODUCTION TO THE
TWENTY-FIFTH ANNIVERSARY EDITION
二十五周年纪念版作者手记

我想，每一个写作者都会梦想获得类似《禅与摩托车维修艺术》这样的成功。过去的二十五年里，它获得高度好评，被翻译成二十三种语言，发行了数百万册。曾有媒体这样介绍它："有史以来被阅读最多的哲学书。"[1]

在七十年代早期写作本书时，我当然也有这样的梦想。但是我不敢多想，也不敢对别人说。因为我害怕被当成自大狂，让人担心我过去的精神问题又要露头。现在，梦想已经变成现实，我再也没什么好担心的了。

但是，与其讲述大家已经看到的成功，不如借此机会写写本书的失误，这不但是一个更好的题材，或许也可以纠正这些失误。其中有两处最为明显——一个次要的，一个主要的。

1 《伦敦电讯报》及BBC广播电台。——原注

次要失误是，斐德洛（Phaedrus）这个名字，在希腊语中的意思并不是"狼"。这个错误源于我一九六〇年在芝加哥大学的真实经历，出现在书中的第四部。哲学教授提到，柏拉图喜欢给他书中的人物起一个反映其本性的名字，在《斐德洛篇》中，里面的人物就像一匹狼。这名教授，我记得他的真名是拉姆（Lamm），也可能是兰姆[2]，当时看我的眼神仿佛在对我说，他认为狼这个称呼适合我。我总是以局外人的姿态对待课堂上讲授的内容，我的注意力更多用在了从中挑毛病，而不是吸收有用的东西上。我激越的头脑令我始终和学校处于紧张的关系中，这一点也反映在了书中。然而，被柏拉图比作狼的人物并不是斐德洛（Pheadrus），而是吕西亚（Lycias），他的名字和希腊语 lykos 很像，后者的意思正是"狼"。正如很多读者已经向我指出的，Phaedrus真正的意思是"极其聪慧的"或"光芒四射的"。我真走运，这个词完全可能意味着某些更糟糕的东西。

第二个失误则严重得多，因为它使本书的一个重要情节模糊不清。很多读者注意到，结尾没有把故事讲清楚，有些事情省略了。有人说这样一个"好莱坞式的结局"损害了本书的艺术完整性。他们说得没错，除了一点，那个好莱坞式的结局并不是我的本意。原本的结局大不相同，可是它太模糊了。在那个结局里，并不是讲述者战胜了邪恶的斐德洛，而是正直的斐德洛战胜了一

[2] Lamb，意为小羊。——编者注

直在抹黑他的讲述者。在二十五周年的纪念版中，通过把斐德洛的话用楷体字印刷出来，使我的本意清晰多了。

就这个话题多说两句，我想讲讲五十年代早期我在明尼苏达大学学习创意写作的往事。讨论班安排在冬日下午，老师是艾伦·泰特（Allen Tate），一位杰出的诗人和文学评论家。有好几次课我们都在讨论亨利·詹姆斯（Henry James）的《螺丝在拧紧》（The Turn of The Screw）。这个故事讲述了一位女家庭教师在一栋鬼魂出没的房子里竭力保护她的两个学生，但她最终失败了，两个学生都死了。在我眼中这完完全全就是一个鬼故事，但泰特说并非如此，亨利·詹姆斯没这么简单。女教师并不是这个故事里的英雄，而是这个故事里的真凶。杀死孩子的不是鬼魂，而是她相信房子里存在鬼魂后的疯狂。我一开始对他的说法难以置信，但是重读一遍这个故事后，我认识到泰特是对的。这两种解读都能成立。

我怎么就没有读出来呢？

泰特的解答是，詹姆斯通过使用第一人称叙述制造了这种奇特的效果。泰特说，第一人称是最难的写法，因为作者被封闭在讲述者的头脑里无法脱身。他不能写"与此同时，在农场上正……"来切换到不同的话题，因为他从始至终都被囚禁在讲述者的视角中。但是，读者又何尝不是！这就是第一人称叙事的力量。读者看不出女教师才是真凶，因为读者是通过女教

在伐木道上露营，一九六八年七月
拍摄地点：爱达荷州

正文P319	伐木专用道上全是沙子，所以我换到低速挡，把脚伸出去，以免栽倒。从主路上我们看到还有其他的小路，但是我们仍然骑在主路上。大约骑了一英里，看到一些推土机，这表示他们仍在这里伐木，于是我们就回过头来，骑到一条小路上。大约又骑了半英里之后，有一棵树横倒在路中央——这表示这条路已经废弃了。很不错。
波西格注	爱达荷的林中道路——这是第24章开篇的场景：我爬出睡袋。外面的寒气很重，于是我赶快把衣服穿上。克里斯仍然在睡，我绕过他，跨过一棵倒在路旁的枯树，走到伐木专用道上。我先慢跑热身，然后沿着路飞快地跑着。（正文P323。）

师的眼睛看到的一切。

现在回到《禅与摩托车维修艺术》，不难看到这种相似之处。同样有一个叙述者，你从始至终都无法脱离他的视角。他提到一个邪恶的鬼魂，名字叫斐德洛，但你了解到这个鬼魂很邪恶的唯一途径是通过这个讲述者的话。在这个故事里，讲述者几次梦到斐德洛，通过这些梦境你逐渐看到，不仅是讲述者在寻找斐德洛，期望消灭他，斐德洛也带着同样的目的在寻找讲述者。谁会胜出呢？

这是一个分裂的人：他有两个心灵，在争夺同一个身体。"精神分裂症（schizophrenia）"一词的原意就是指这种情况。这两个心灵对于人生中什么是重要的，有着不同的价值选择。

讲述者基本上是一个被社会价值观支配的人。正如他在开篇所说："我已经很多年没有新的思想了。"除了讲一些精心设计过的台词，他从不袒露心扉，为的是让你喜欢他。他的内心想法可以说给你听，但不能说给约翰、思薇雅、克里斯或狄威斯听。总而言之，他不愿被你——读者们——所孤立，或者说，不愿被周遭的社会所孤立。他小心地行走在他所身处的社会的常规界限之内，因为他曾目睹在界限外行事的斐德洛所遭遇的事情。有斐德洛的教训在前，他可不想接受什么电击疗法。只有一处，这个讲述者坦承了自己的秘密：他说他是一个异教徒，所有人都称赞他挽救了他的灵魂，但只有他自己知

一点儿没错，在俄勒冈州中部的这个区域，森林和泥土就是这个样子
拍摄地点：俄勒冈州的拉派恩北侧

正文P383	我们继续往南走，抵达一片森林。里面的树木划分成许多可笑的小区域。很显然，这原是拓荒者的规划。在离高速公路有一段距离的地方，我们把睡袋铺开，这才发现松针压住了好几英尺厚的灰尘。
波西格注	俄勒冈的清晨——出自第28章。你能在背景中认出一顶白色头盔和一旁的睡袋，克里斯正在里面睡觉。与之对应的原文为：外面寒冷彻骨，就好像冬天一样。我们在哪里？竟然会这么冷！我们一定是在一个很高的地方。我从睡袋里望出去，看到摩托车上有霜。油箱上的露珠在晨光的照耀下正闪闪发亮。（正文P390。）

道，他挽救的只是他的躯壳。

只有两个人知道，或者感觉到了这一点。一个是克里斯。他带着困惑和伤痛寻找那个他记忆中深爱的父亲，可怎么也找不到，因此几近崩溃。另一个是斐德洛，他完全知道这个讲述者的心思，因此鄙视他。

在斐德洛眼中，讲述者是一个叛徒，一个懦夫。他背弃了真理去谋求虚荣，换取精神病医生、家庭、雇主和社交圈子的接纳。他看出这个讲述者再也不想说实话了，他安于做被群体接纳的一员，在卑躬屈膝中度过余生。

斐德洛是被知识价值所支配的人。他根本不在乎别人喜不喜欢他，一门心思追求他认为具有惊世的重要性的真理。这个世界完全不理解他为何奋斗，并且因为他惹出的麻烦想要消灭他。现在，他已经在社会上被消灭——再也不能发声了。但他思想的碎片仍然存留在讲述者的脑中，这就是冲突的根源。

最后，是克里斯的痛苦不堪解救了斐德洛。克里斯问："你那时真的疯了吗？"得到的回答是"不"。回答他的不是讲述者，而是斐德洛。而当克里斯说"我就知道"时，他也知道自己是在整个旅途中第一次和他失散已久的父亲再次对话。矛盾解开了，他们赢了。那个心怀鬼胎的讲述者消失了。"情况正在慢慢好起来，"斐德洛说道，"我们几乎可以这样期待。"